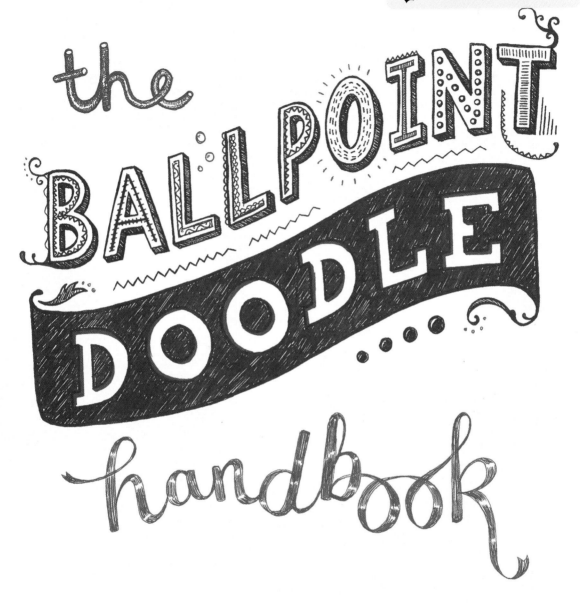

the BALLPOINT DOODLE handbook

Sarah SKEATE

ilex

An Hachette UK Company
www.hachette.co.uk

First published in the UK in 2017 by ILEX,
a division of Octopus Publishing Group Ltd

Carmelite House
50 Victoria Embankment
London EC4Y 0DZ
www.octopusbooks.co.uk

Publisher: Roly Allen
Editorial Director: Zara Larcombe
Managing Specialist Editor: Frank Gallaugher
Editor: Rachel Silverlight
Admin Assistant: Stephanie Hetherington
Art Director: Julie Weir
Designer: Louise Evans
Assistant Production Manager: Lucy Carter

ISBN 978-1-78157-544-4

A CIP catalogue record for this book is available
from the British Library.

Printed and bound in China

10 9 8 7 6 5 4 3 2 1

INTRODUCTION!

We love doodling.

We doodle in notebooks when we're bored (but supposed to be paying attention), we doodle absent-mindedly on the backs of envelopes (when we really are paying attention), and sometimes ... we even doodle on each other!

The *Ballpoint Doodle Handbook* is designed to be doodled all over, and not only does it provide the perfect place to let your pen go for a wander, but it also gives you loads of fun ideas and techniques to try out too.

TEXTURES

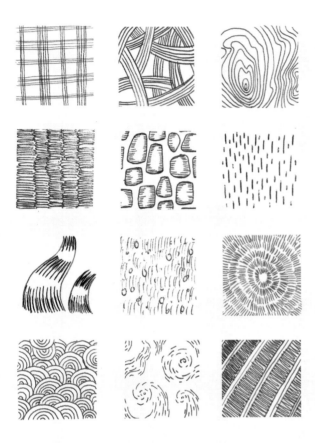

Here are some textures you can try out in pen.
Try inventing your own—there are endless kinds
to create. Take inspiration from nature, man-made
materials, and so on, then draw an object, character,
or scene, and fill it in. There are no rules.

Have fun and experiment!

→ Bll Cypher

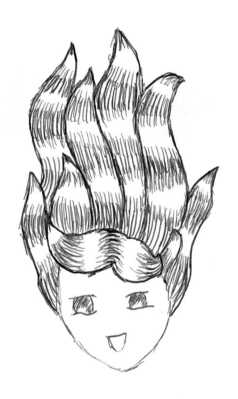

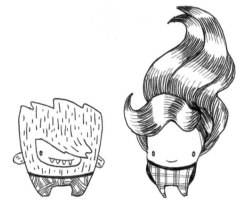

HATCHING, SCUMBLING & STIPPLING

Unlike with pencil, it is difficult to add tonal value (that is, make darker) to your drawing just by increasing the pressure you apply to your pen. You can, however, add tone by using specific strokes. Below are some popular techniques.

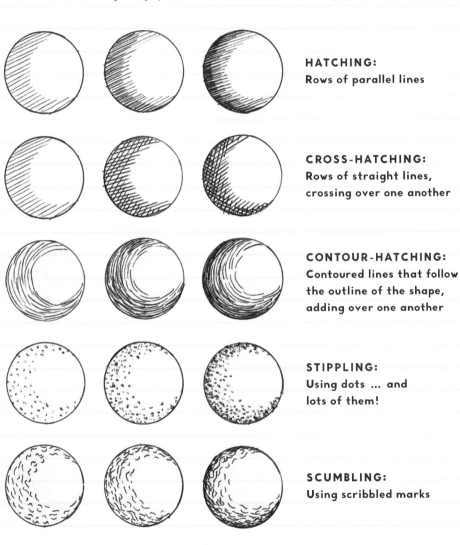

HATCHING:
Rows of parallel lines

CROSS-HATCHING:
Rows of straight lines, crossing over one another

CONTOUR-HATCHING:
Contoured lines that follow the outline of the shape, adding over one another

STIPPLING:
Using dots ... and lots of them!

SCUMBLING:
Using scribbled marks

WARNING: Too much stippling and scumbling could make you go cross-eyed!

Hatching is good for adding form and depth to solid, unmoving structures.

Stippling provides a smooth but finely textured surface to objects.

Scumbling gives this bear a furry texture and adds form and depth.

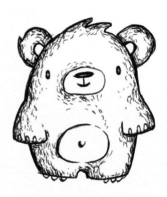

Employ a mixture of textures to portray different surfaces and add depth...

FUNNY FACES

When creating funny faces,
think about *extremes*:

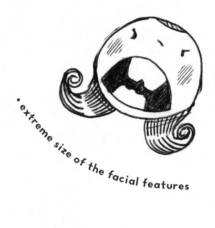

extreme size of the facial features

extreme position of facial features

extreme facial feature shapes

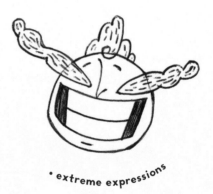

• extreme expressions

• extreme hair

For these faces I've drawn a basic oval shape, then added the features, thinking about the extremes listed above—e.g. if they have small eyes/nose, I give then a large mouth; or big hair with tiny features.

You don't need very expressive features to give a sense of character when you've got a wild beard and a rather large nose!

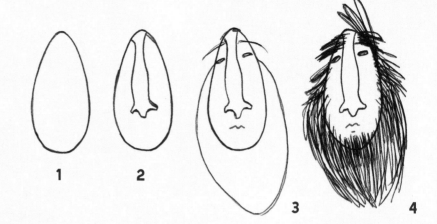

This lady's features are uncomfortably crammed in the upper half of her face outline.

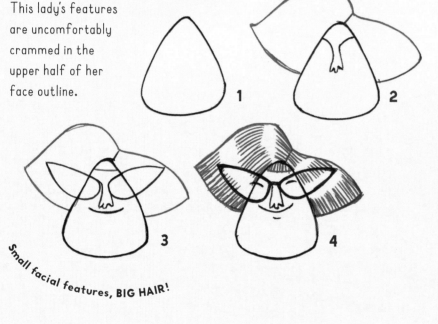

Small facial features, BIG HAIR!

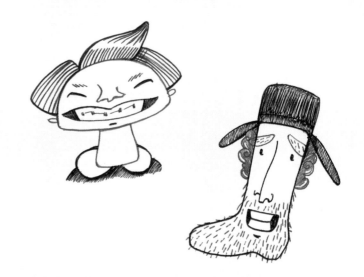

 Take inspiration from everyday objects, like mushrooms, vacuums, and socks.

CREATE _Cute_ ANIMALS

Look at pictures of animals for reference. Make the main part of the body a very simple shape. Detail should focus on the features that define the animal.

HERE ARE SOME SIMPLE EXAMPLES FOR INSPIRATION:

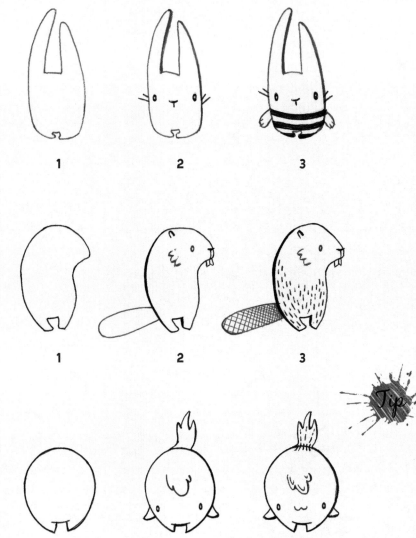

1 **2** **3**

1 **2** **3**

1 **2** **3**

You can create cute characters using simple shapes—you only need one shape that suggests head, body, and legs. Then add basic features.

Tip

A good technique for ensuring that facial features fit the cute formula is to draw the eyes first and use them as a landmark to position your nose and/or mouth. This also helps you to keep the face symmetrical.

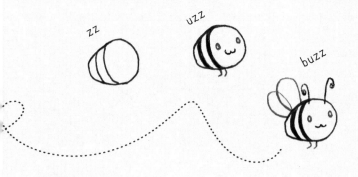

Get *creative* with that cute look here!

do a doodle: take a line for a walk!

Marvelous Motion!

Adding movement can really
bring your drawing to life.

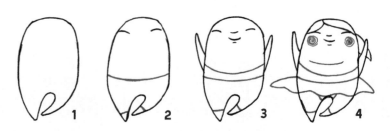

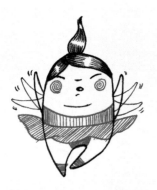

**Trying to fly! Imply
motion, by drawing
multiple arms.**

**Remember to keep the
arms attached to the
shoulder! They should join
the body in the same place.**

**The facial features are
moved toward the top
of the head, as if she
is looking upward.**

Falling:
Add vertical
motion marks.
Hair and tutu
flying upward.

Here, hair is important for
showing how the direction
of the body and the way
it's moving.

I'm a winner! Head
up with confidence,
and looking forward.
She has her eyes
on the prize!

THESE GUYS ARE FEELING PRETTY CHILLY UP TOP!

Go wild with facial hair and some inspired headgear:

Fantastically Furry

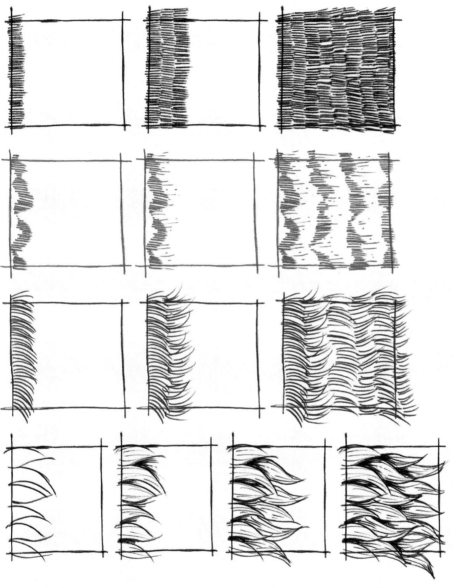

There are many ways to create a furry texture in pen. Below are some step-by-step examples, modeled by a little beastie on the opposite page.

Practice here:

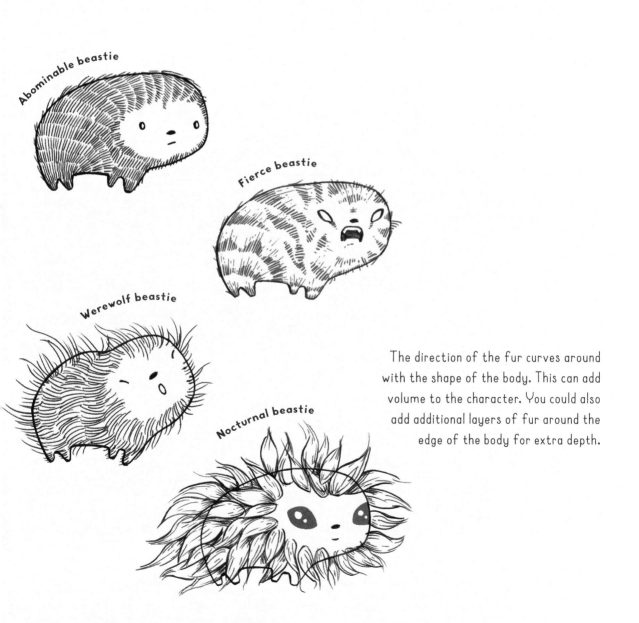

Abominable beastie

Fierce beastie

Werewolf beastie

Nocturnal beastie

The direction of the fur curves around with the shape of the body. This can add volume to the character. You could also add additional layers of fur around the edge of the body for extra depth.

ALIEN INKCOUNTERS

These creatures need to be *out of this world*, so start by drawing an abstract shape for the body and head.

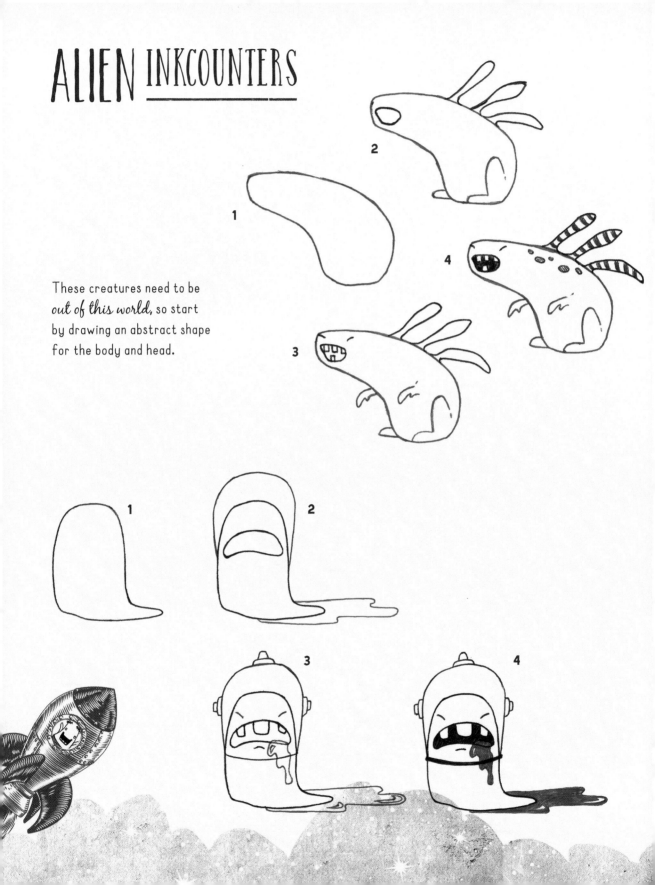

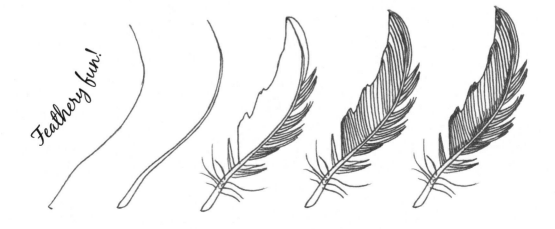

Feathery fun!

STACK THEM UP

Draw shape...

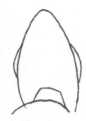

Legs and arms?

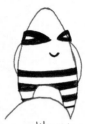

Color like this?

No, this way!

Let their shape and position among others give you ideas for facial expressions, character, and stance.

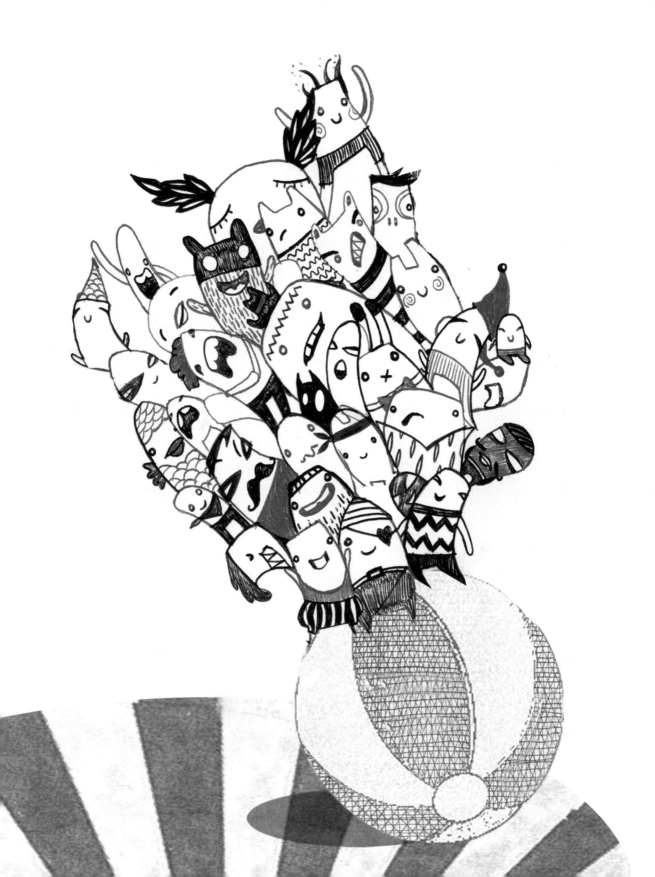

Practice drawing
simple shapes...

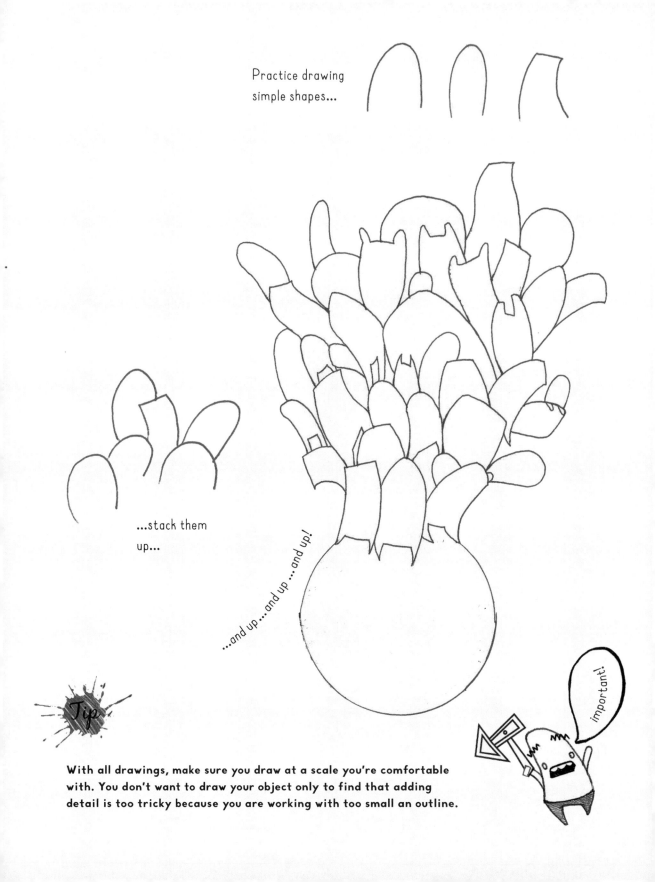

...stack them
up...

...and up...and up...and up!

Tip

important!

With all drawings, make sure you draw at a scale you're comfortable
with. You don't want to draw your object only to find that adding
detail is too tricky because you are working with too small an outline.

STUPENDOUS SCALES

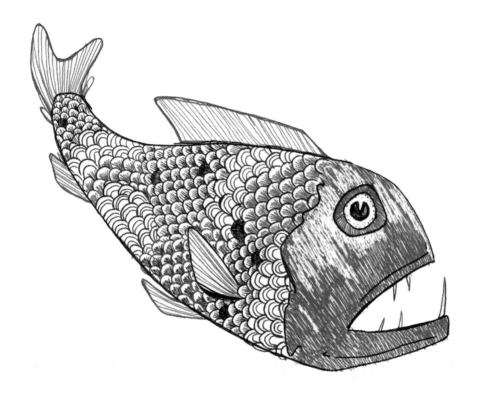

Here are two simple ways
to suggest scales using pen.
You can mix the versions
together to great effect.

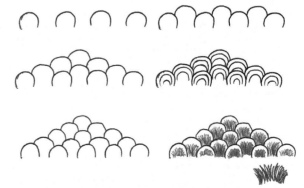

HOW
does your GARDEN GROW?

I've taken inspiration from old engravings of plants and flowers to create a unique garden. Create your own genetically engineered array of the weird and wonderful, then add them to the garden overleaf...

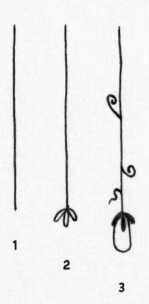

1 2 3

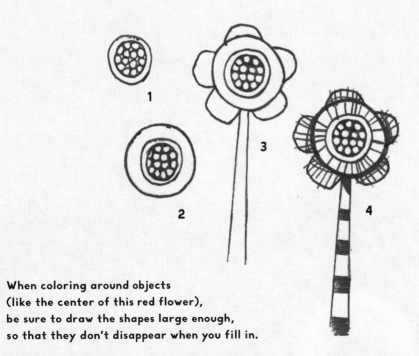

**When coloring around objects
(like the center of this red flower),
be sure to draw the shapes large enough,
so that they don't disappear when you fill in.**

Don't always go for conventional flower and leaf shapes. I've used simple shapes like circles and ovals.

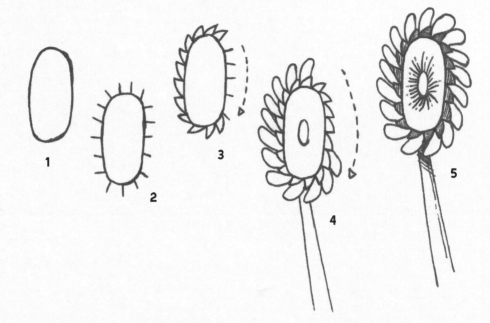

When filling in the plant/flower detail, this is more about mark-making. Then add lots of subtle, natural-looking details.

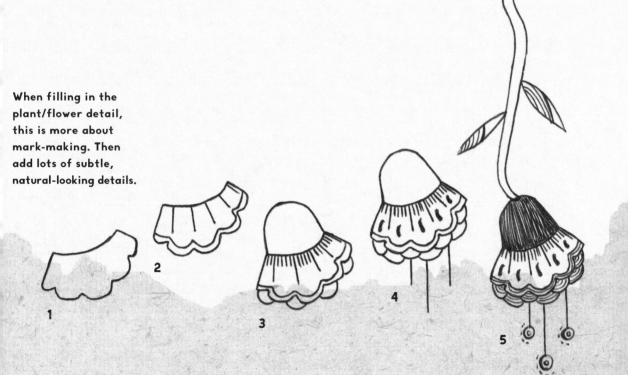

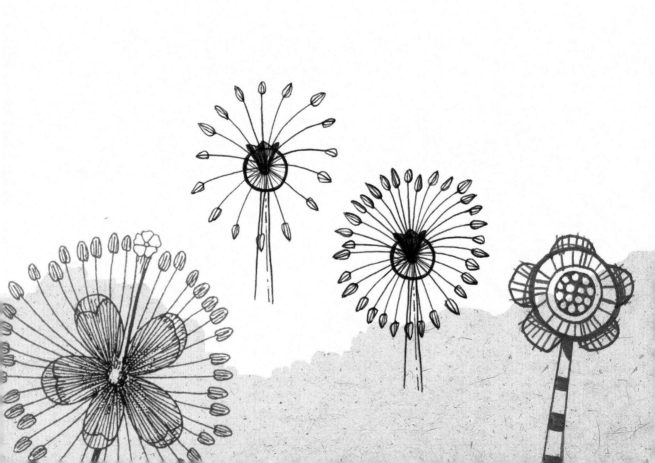

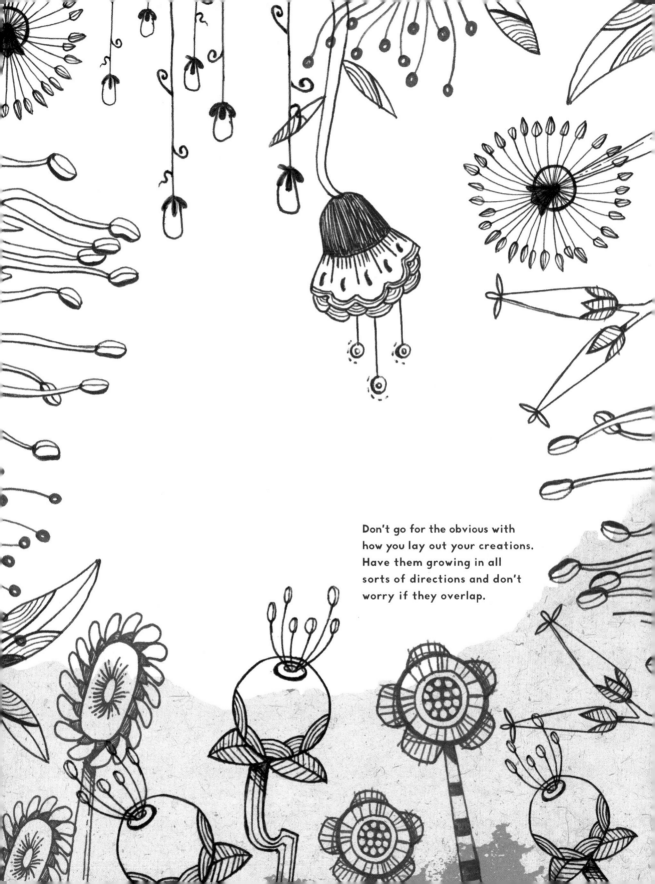

Don't go for the obvious with
how you lay out your creations.
Have them growing in all
sorts of directions and don't
worry if they overlap.

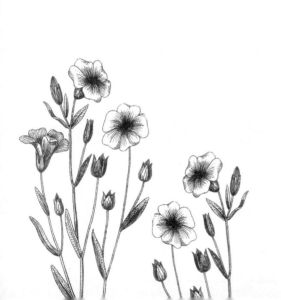

Picture Perfect BORDERS

How you frame a picture can be as important as the picture itself, whether it's for a photo or a drawing. Here are some ways to pen a decorative border in ballpoint.

Simple borders using a straight line:

Close-up of leaves with steps

Try an organic flowering border yourself on the opposite page

ORNATE BORDERS

When drawing details around the frame with a repeated motif, start at a central point, as shown by the arrows...

...This will help you keep each motif a uniform size, as you draw around the frame.

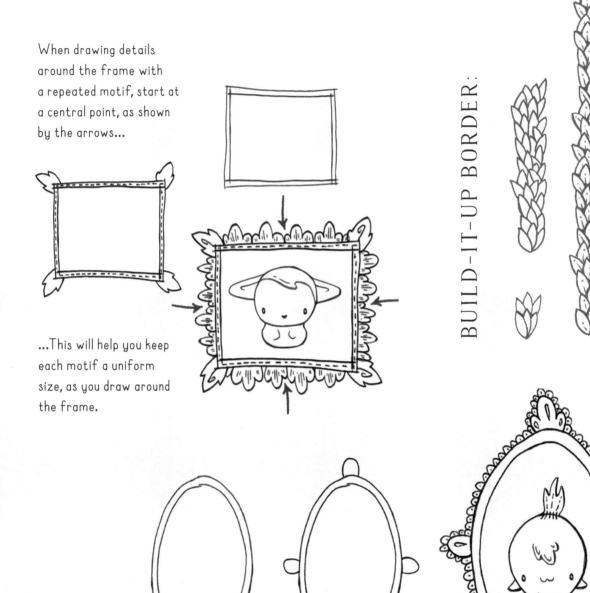

BUILD-IT-UP BORDER:

Tip As you draw around the drawn frame, rotating the page can help keep your arm/pen at a comfortable angle.

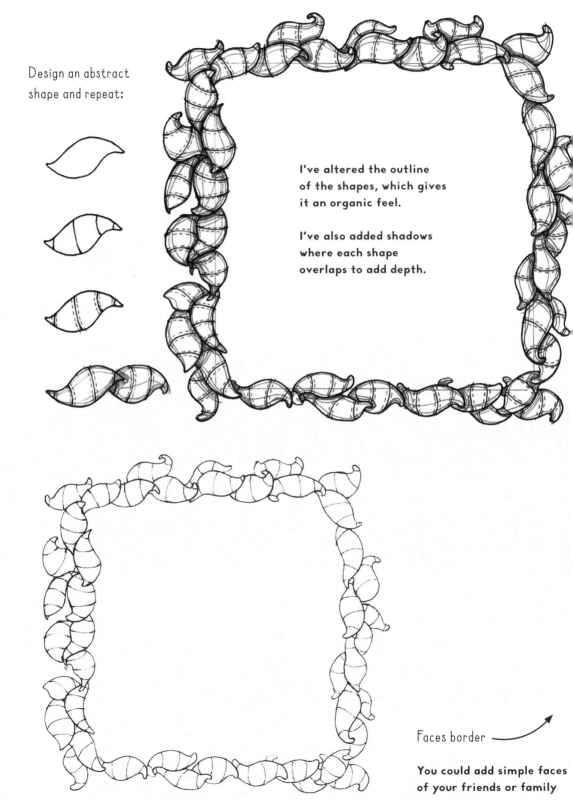

Design an abstract
shape and repeat:

I've altered the outline
of the shapes, which gives
it an organic feel.

I've also added shadows
where each shape
overlaps to add depth.

Faces border

You could add simple faces
of your friends or family

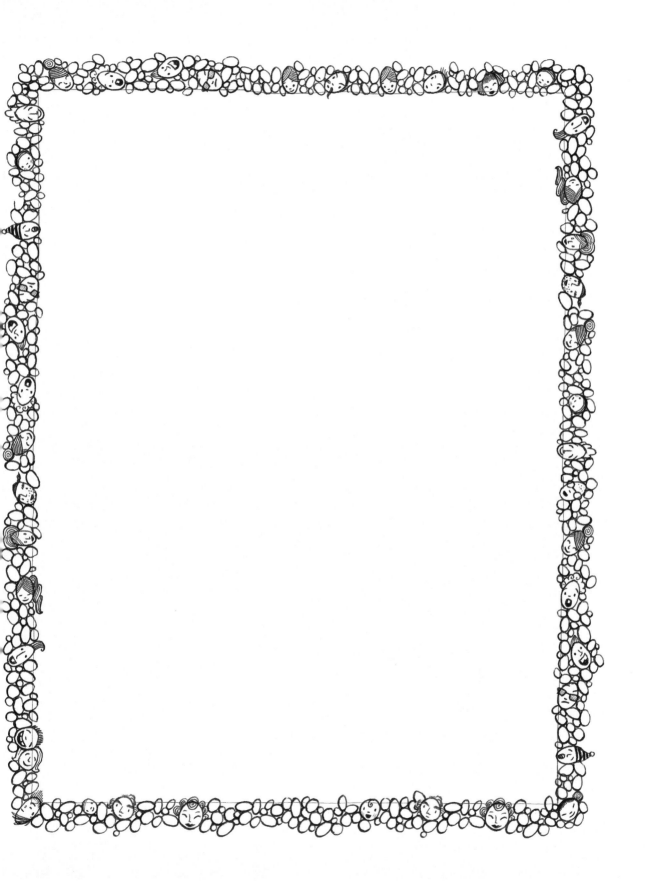

Try building up a spooky Day of the Dead border!

1

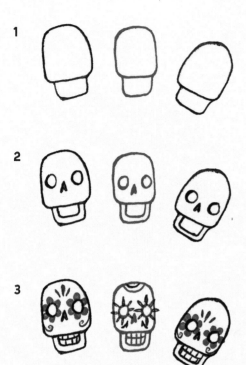

2

3

Artistic **Alphabets**

Here are some simple ways to draw decorative letters:

You can use the basic
outline and embellish with
your own touches...

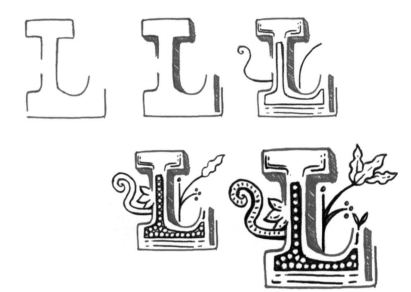

Draw a simple block letter and embellish around the outside.
Here's a 3-D letter that could use some decoration...

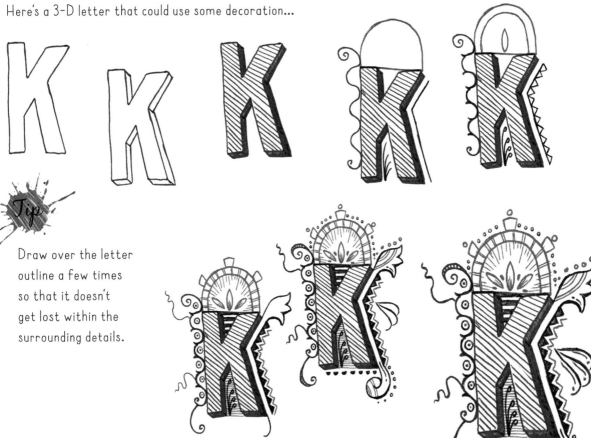

Draw over the letter
outline a few times
so that it doesn't
get lost within the
surrounding details.

PATTERNS *in Pen...*

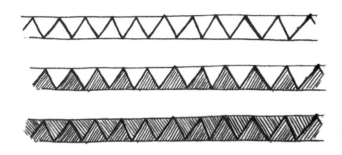

Patterns can be made from absolutely anything—for example simple mark-making, shapes, objects, animals, etc.—as long as you repeat the design.

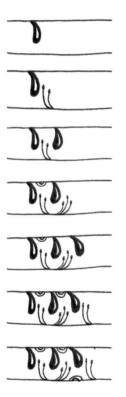

Patterns by definition are a repeated design but drawing in only pen doesn't allow us to be precise. So I'm going to draw freehand and not worry about winning prizes for accuracy!

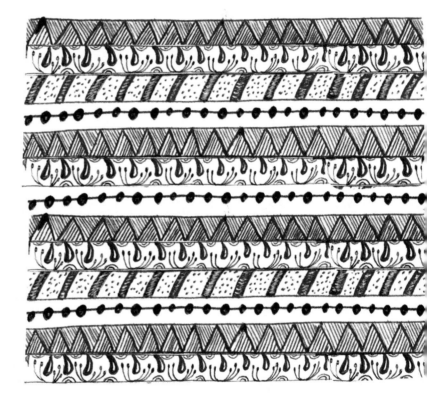

NATURE:

This pattern looks complex, but broken down it's quite simple.
The only challenge is to keep focused on the repeated pattern,
in terms of what goes where, so that you don't make a mistake.

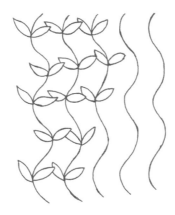

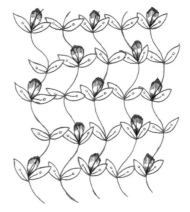

Draw parallel wavy lines.

Draw two leaves on every bend. Thicken the outline.

Add leaf detail, then a blue feather motif on each alternate pair of leaves.

Feather detail:

1 2 3 4

1

2

Plus teeth!

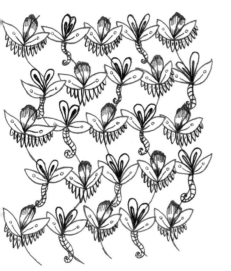

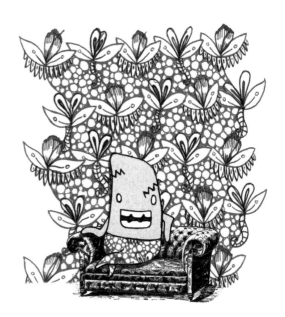

When tackling a repeat pattern,
drawing a grid first can help give
you confidence:

1

2

3

Swirl to give impact.

I added shadow beneath lollipop.

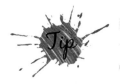

Make sure your grid is big enough, so that when you're adding the pattern, you are working at comfortable scale.

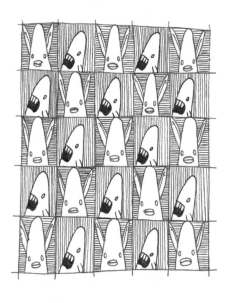

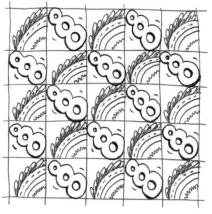

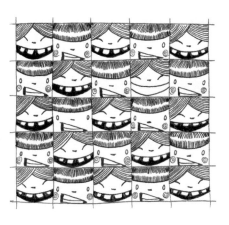

Have a try with this grid!

Could there be a menacing *monster* in your closet??

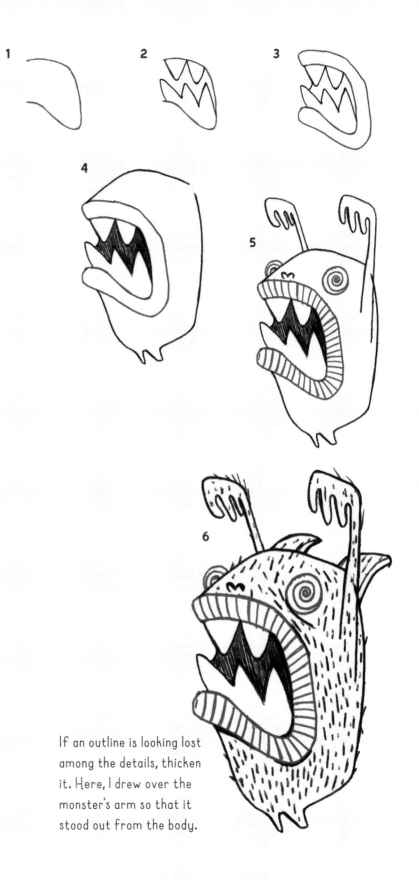

1

2

3

4

5

6

If an outline is looking lost among the details, thicken it. Here, I drew over the monster's arm so that it stood out from the body.

Tip For drawings that involve a lot
of detail, draw each line slowly.
This will give your brain more
time to tell your hand and eyes
how each line should progress in
terms of direction and shape.

BETWEEN THE LINES

Use the lines to draw a frame, then fill in with a pattern:

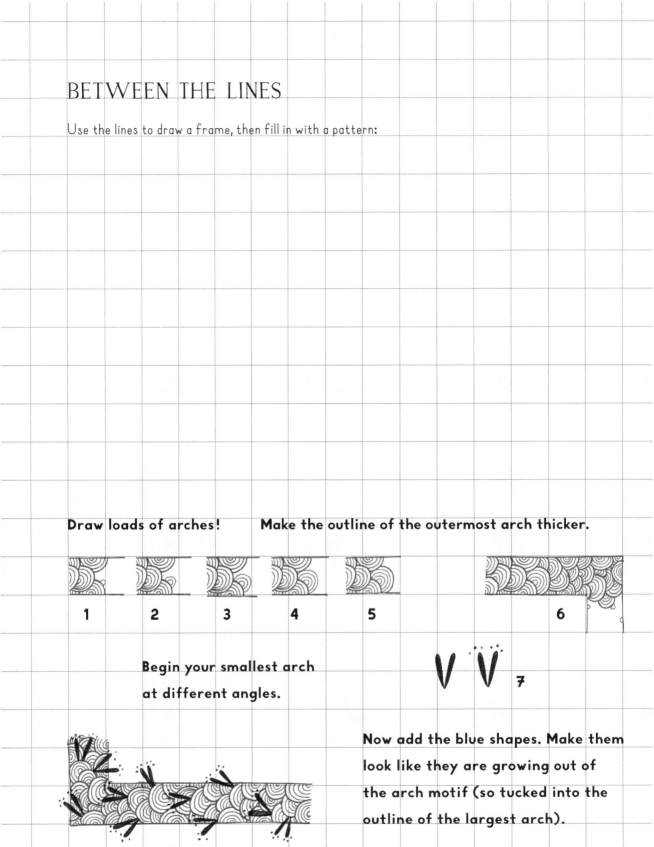

Draw loads of arches! **Make the outline of the outermost arch thicker.**

1 2 3 4 5 6

Begin your smallest arch at different angles.

7

Now add the blue shapes. Make them look like they are growing out of the arch motif (so tucked into the outline of the largest arch).

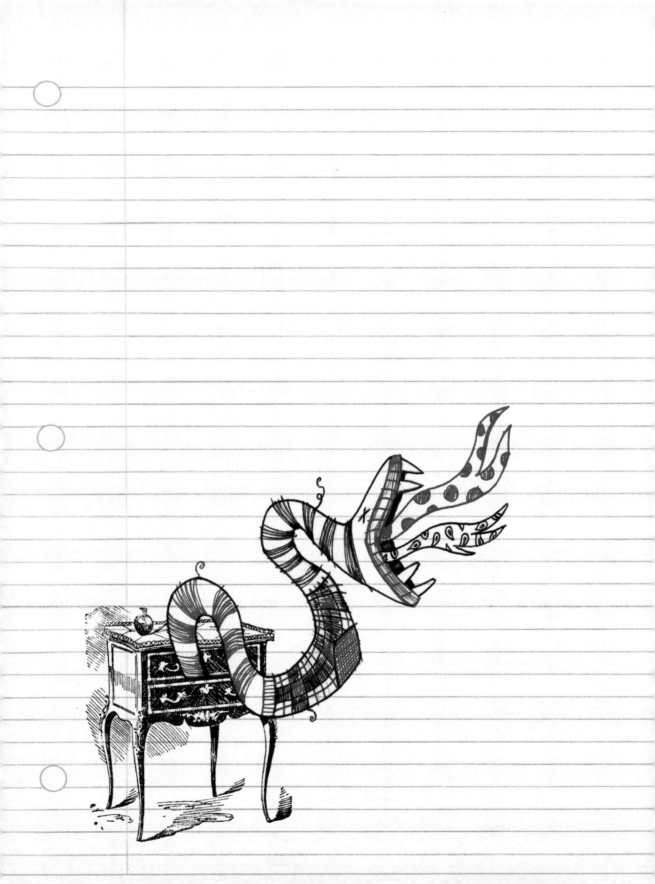

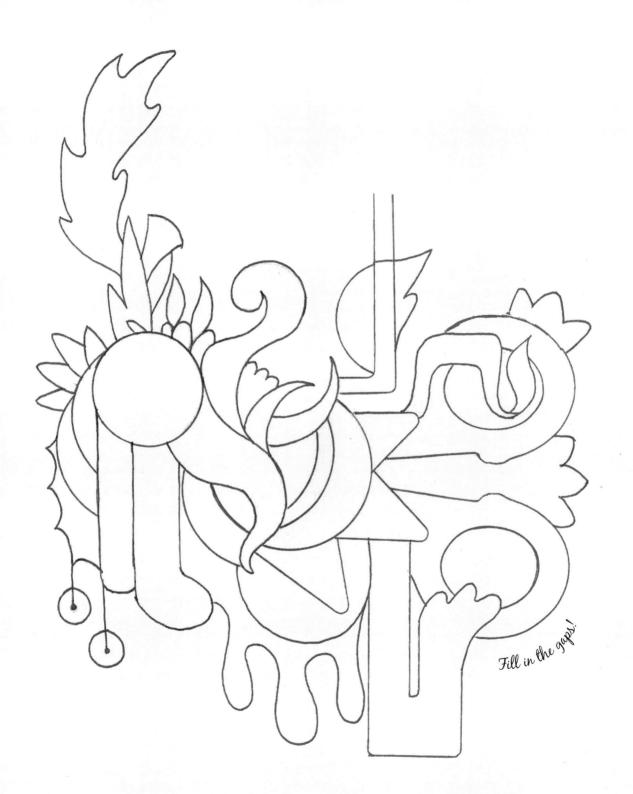

Fill in the gaps!

Ceaseless CITYSCAPE

Draw a stack-them-up cityscape using basic cuboid shapes:

Tip

Draw the facing square/rectangle of your cuboid first and then the diagonal lines.

Put that ruler down—no need to be precise!

Try to keep these three lines parallel to one another.

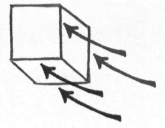

Try to keep all the horizontal and vertical lines parallel to their counterparts.

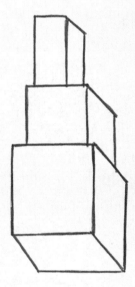

STACK THEM UP LIKE BUILDING BLOCKS

Start with the bigger-sized cuboids at the bottom. They gradually get smaller as they stack up. See how the bottom box is complete but those stacked above have lines that stop before they cross over the box below. Draw all the cubes using red pen, as some lines will cross over and you might want to cover them up by shading in a darker color.

Have a practice here:

KEEP ON BUILDING

There will be shading-in later, so draw over each line a couple of times to make them stand out.

If you draw a larger box on top of a smaller one, here's how to finish the cuboid shape:

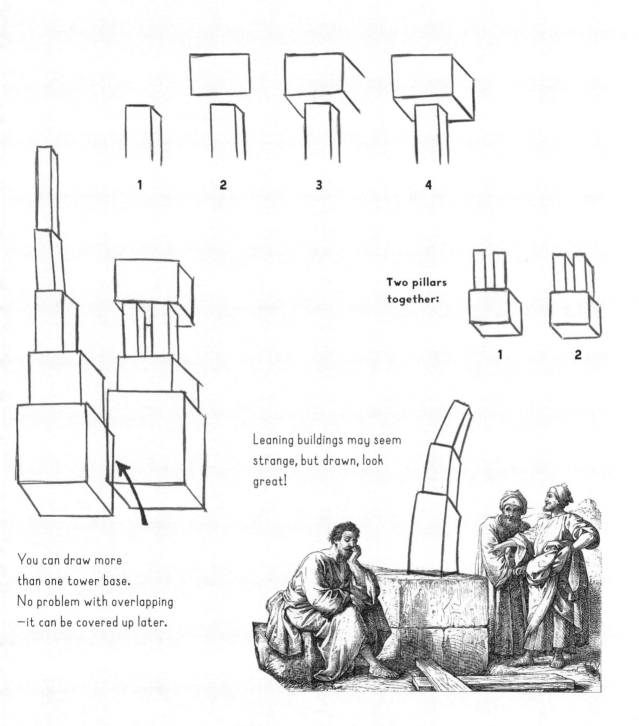

1 **2** **3** **4**

Two pillars together:

1 **2**

Leaning buildings may seem strange, but drawn, look great!

You can draw more than one tower base. No problem with overlapping —it can be covered up later.

Simple *windows*...

Different windows with different *reflections*...

**Diagonal lines
of light**

**Reflection of
buildings opposite**

**Reflection of
clouds passing by**

**Diagonal lines
across multiple
windows**

Adding *shading* to your block buildings can add form
and depth. Below are some examples...

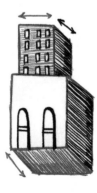

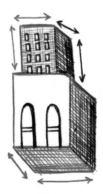

Straight lines:
Parallel to the outlines
of the building

Cross-hatched lines:
Parallel to the outlines
of the building

Stippling:
For the very patient!

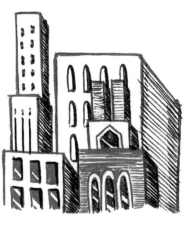

Practice here. You can even try adding to my city below:

You can draw buildings behind your front row of buildings. It's best to keep them larger, with simple, light shading so the cityscape doesn't become too busy and confusing.

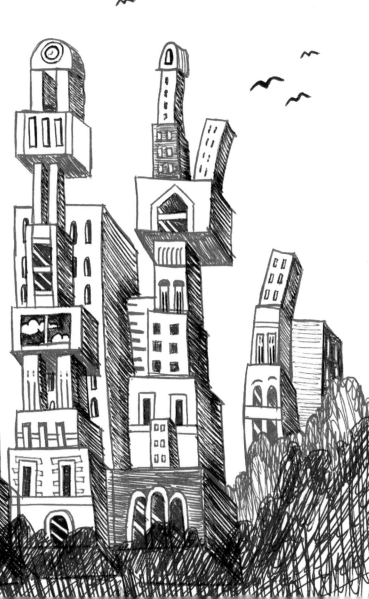

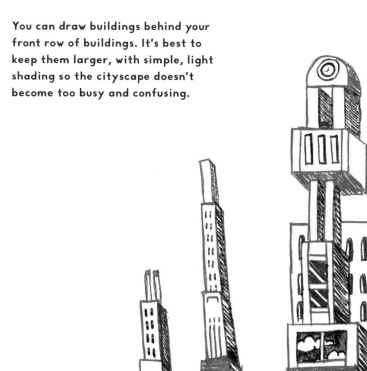

SQUIGGLE CREATURES

Draw a loose squiggle shape. Don't think too much about what
shape you are drawing. Look at your squiggle. Think where
you'd want to position the face first.

You can emphasize
a character's mood
based on where you
position its face
within the squiggle
shape...

...low down for a scowl...

...high up to look gleeful!

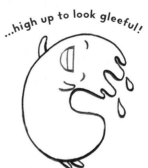

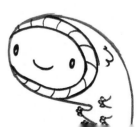

of the stage whom he most admired were not those of the highest type. He was subdued by the genius of Frédéric Lemaître, but blind and deaf to that of Ristori. "Sound melodrama and farce" were the dramatic species which he affected, and in which as a professional actor he might have excelled. His intensity might have gone for much in the one, and his versatility and volubility for more in the other; and in both, as indeed in any kind of play or part, his thoroughness, which extended itself to every detail of performance or make-up, must have stood him in excellent stead. As it was, he was preserved for literature. But he had carefully prepared himself for his intended venture, and when he sought an engagement at Covent Garden, a preliminary interview with the manager was postponed only on account of the illness of the applicant.

Before the next theatrical season opened he had at last —in the year 1831— obtained employment as a parliamentary reporter, and after some earlier engagements he became, in 1834, one of the reporting staff of the famous

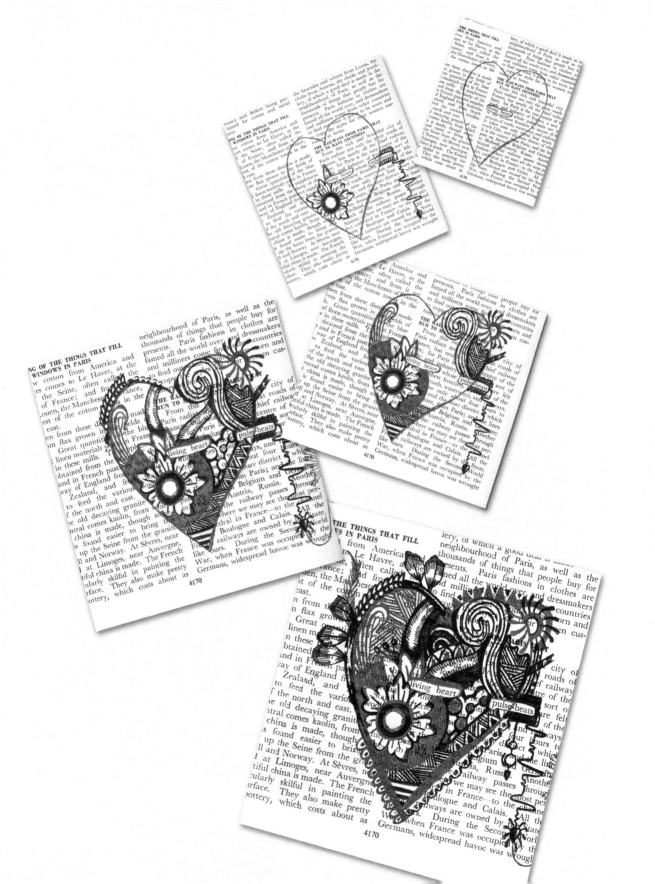

SIMPLE CITYSCAPE

I've found a few photos of buildings I like the look of, from which
I'm going to draw a cityscape. This is a lot *simpler* than it sounds...

1. Draw outline of the building first.

**2. Add basic window shapes. I've
added a shadow to each window.**

**3. The only other detail in
this case is brickwork at top
and bottom of each window.**

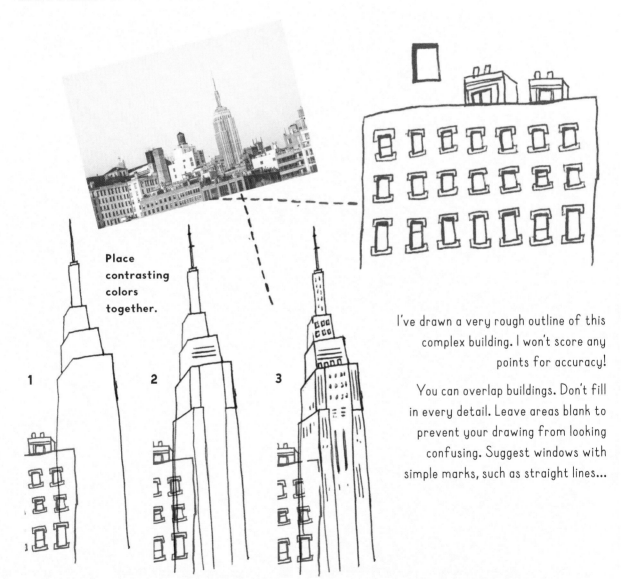

**Place
contrasting
colors
together.**

1 2 3

I've drawn a very rough outline of this
complex building. I won't score any
points for accuracy!

You can overlap buildings. Don't fill
in every detail. Leave areas blank to
prevent your drawing from looking
confusing. Suggest windows with
simple marks, such as straight lines...

Put smaller buildings in the foreground and big ones,
like skyscrapers, toward the back. You can add a few
more of the finer details to the foreground buildings.
Make sure the building outlines clearly overlap,
rather than sit on top of one another.

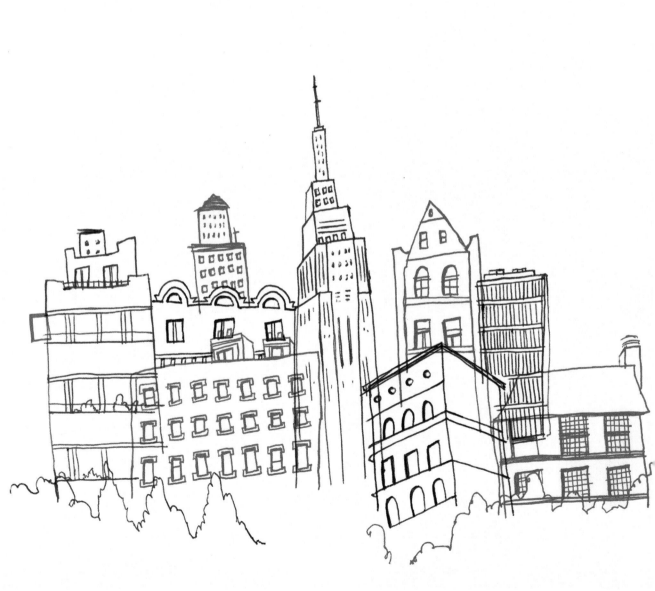

Flower POWER!

Here are some flowers to draw and repeat. They are not as complicated as they look. Just take one step at a time...

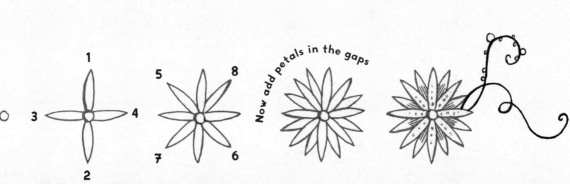

Now add petals in the gaps

Draw the petals in the order they are numbered above. This helps you to position them evenly.

Add a pattern to the petals and vines.

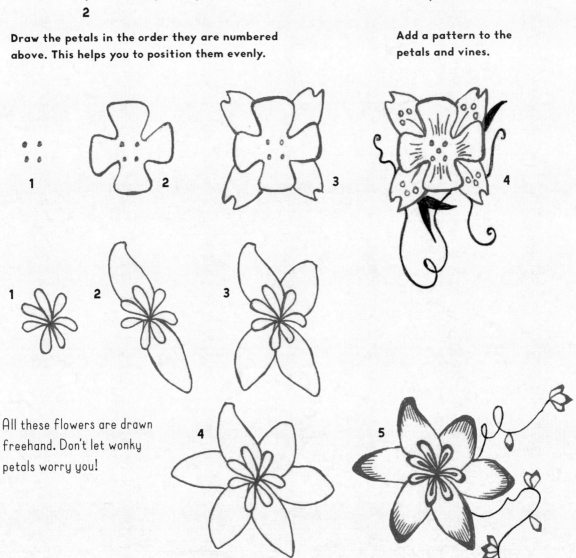

All these flowers are drawn freehand. Don't let wonky petals worry you!

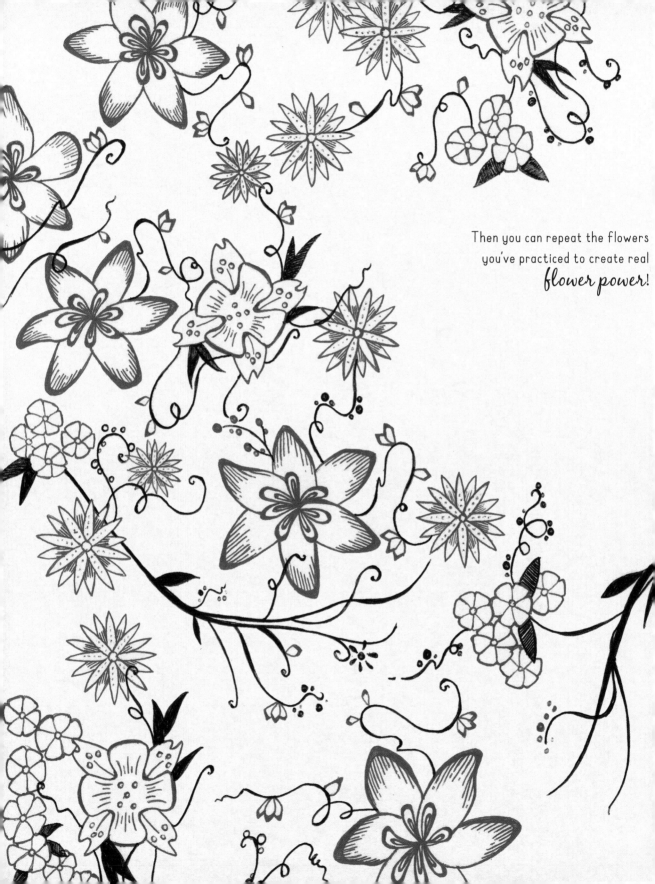

Then you can repeat the flowers
you've practiced to create real
flower power!